GW00598085

NATIONAL GEOGRAPHIC™

ADDRESS
BOOK

PERSONAL FILE

name _____

home address _____

_____ postcode _____

telephone _____

mobile _____

email _____

business address _____

_____ postcode _____

telephone _____

mobile _____

email _____

passport number _____

national insurance number _____

car registration _____

driving licence number _____

insurance number _____

◀◀ Shuttered window, Manolas, Thirasia Island, Greece.
Photograph by James P. Blair

national health number _____

blood group _____

any known allergies _____

doctor _____

address _____

_____ postcode _____

telephone _____

dentist _____

address _____

_____ postcode _____

telephone _____

bank _____

address _____

_____ postcode _____

telephone _____

WORLD TIME ZONES

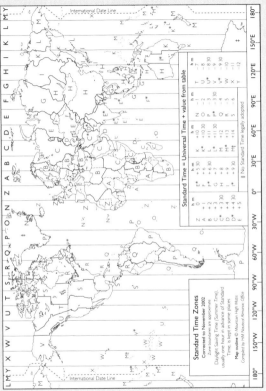

International Date Line

Standard Time = Universal Time + value from table

	h m			h m
E*	+ 5.30	T	U	− 7
F	+ 6			− 8
F*	+ 6.30	U		− 8.30
G	+ 7	V		− 9
H	+ 8	V*		− 9.30
I	+ 9	p*		− 10
K	+10	W		− 11
K*	+10.30	X		− 12
L	+11	Y		
L*	+11.30			
M	+12			
M*	+13			
M†	+14			

Standard Time = Universal Time + value from table

	h m			h m
N	− 1	K		+10
O	− 2	K*		+10.30
P	− 3	L		+11
P*	− 3.30	L*		+11.30
Q	− 4	M		+12
R	− 5	M*		+13
		M†		+14

‡ No Standard Time legally adopted

Standard Time Zones

Corrected to November 2002
Zone boundaries are approximate.
Daylight Saving Time (Summer Time),
usually one hour in advance of Standard
Time, is kept in some places

Map outline © Mountain High Maps
Compiled by HM Nautical Almanac Office

International Date Line

This information is reproduced, with permission, from data supplied by HM Nautical
Almanac Office © Council for the Central Laboratory of the Research Councils.
This is not an official map. Countries change their time zones when and as they wish.

DIALLING CODES

Listed below is a selection of international codes; a comprehensive list can usually be found in a telephone directory.

Country	Dial out	Code	Country	Dial out	Code	Country	Dial out	Code
Algeria	00	213	France	00	33	Pakistan	00	92
Argentina	00	54	Germany	00	49	Peru	00	51
Australia	0011	61	Greece	00	30	Philippines	00	63
Austria	00	43	Hong Kong	001	852	Poland	00	48
Bangladesh	00	880	Hungary	00	36	Portugal	00	351
Belgium	00	32	India	00	91	Romania	00	40
Bolivia	00	591	Indonesia	001	62	Russian Fed'n	8-10	7
Bosnia-H'na	00	387	Israel	00	972	Rwanda	00	250
Brazil	00	55	Italy	00	39	Saudi Arabia	00	966
Cambodia	00	855	Japan	001	81	Singapore	001	65
Canada	011	1	Kenya	00	254	Slovakia	00	421
Chile	00	56	Laos	14	856	South Africa	09	27
China	00	86	Malaysia	00	60	Sri Lanka	00	94
Colombia	00	57	Mexico	00	52	Sweden	00	46
Costa Rica	00	506	Monaco	00	377	Switzerland	00	41
Croatia	00	385	Mongolia	00	976	Taiwan	002	886
Cuba	119	53	Morocco	00	212	Tanzania	000	255
Czech Rep.	00	420	Nepal	00	977	Thailand	001	66
Denmark	00	45	Netherlands	00	31	USA	011	1
Ecuador	00	593	New Zealand	00	64	Venezuela	00	58
Egypt	00	20	Nicaragua	00	505	Vietnam	00	84
Eire	00	353	Nigeria	009	234	Yugoslavia	99	381
Finland	00	358	Norway	00	47	Zimbabwe	00	263

Note: "Dial out" indicates prefix used when dialling overseas *from* the country listed. "Code" indicates prefix used when dialling *to* that country.

A

name _____

address _____

_____ postcode _____

tel _____ mobile _____

email _____

name _____

address _____

_____ postcode _____

tel _____ mobile _____

email _____

name _____

address _____

_____ postcode _____

tel _____ mobile _____

email _____

name _____

address _____

_____ postcode _____

tel _____ mobile _____

email _____

◀◀ Mud brick beehive huts and dwellings in Tell Mardikh, Syria.
Photograph by James L. Stanfield

A

name _____
address _____

_____ postcode _____
tel _____ mobile _____
email _____

name _____
address _____

_____ postcode _____
tel _____ mobile _____
email _____

name _____
address _____

_____ postcode _____
tel _____ mobile _____
email _____

name _____
address _____

_____ postcode _____
tel _____ mobile _____
email _____

A

name _____
address _____

_____ postcode _____
tel _____ mobile _____
email _____

name _____
address _____

_____ postcode _____
tel _____ mobile _____
email _____

name _____
address _____

_____ postcode _____
tel _____ mobile _____
email _____

name _____
address _____

_____ postcode _____
tel _____ mobile _____
email _____

A

name _____
address _____

_____ postcode _____
tel _____ mobile _____
email _____

name _____
address _____

_____ postcode _____
tel _____ mobile _____
email _____

name _____
address _____

_____ postcode _____
tel _____ mobile _____
email _____

name _____
address _____

_____ postcode _____
tel _____ mobile _____
email _____

B

name _____

address _____

_____ postcode _____

tel _____ mobile _____

email _____

name _____

address _____

_____ postcode _____

tel _____ mobile _____

email _____

name _____

address _____

_____ postcode _____

tel _____ mobile _____

email _____

name _____

address _____

_____ postcode _____

tel _____ mobile _____

email _____

B

name _____

address _____

_____ postcode _____

tel _____ mobile _____

email _____

name _____

address _____

_____ postcode _____

tel _____ mobile _____

email _____

name _____

address _____

_____ postcode _____

tel _____ mobile _____

email _____

name _____

address _____

_____ postcode _____

tel _____ mobile _____

email _____

B

name _____
address _____

_____ postcode _____
tel _____ mobile _____
email _____

name _____
address _____

_____ postcode _____
tel _____ mobile _____
email _____

name _____
address _____

_____ postcode _____
tel _____ mobile _____
email _____

name _____
address _____

_____ postcode _____
tel _____ mobile _____
email _____

B

name _____
address _____

_____ postcode _____
tel _____ mobile _____
email _____

name _____
address _____

_____ postcode _____
tel _____ mobile _____
email _____

name _____
address _____

_____ postcode _____
tel _____ mobile _____
email _____

name _____
address _____

_____ postcode _____
tel _____ mobile _____
email _____

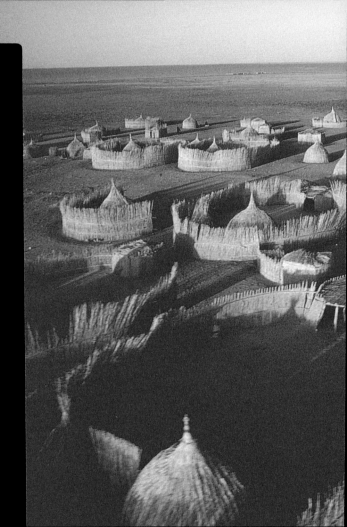

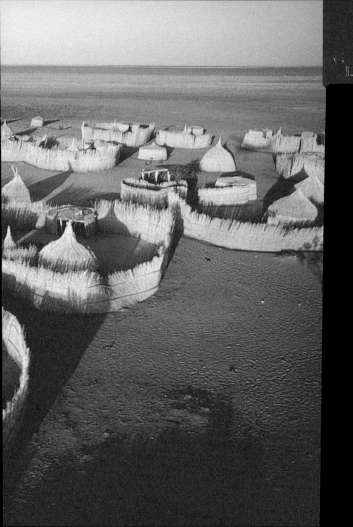

C

name _____

address _____

_____ postcode _____

tel _____ mobile _____

email _____

name _____

address _____

_____ postcode _____

tel _____ mobile _____

email _____

name _____

address _____

_____ postcode _____

tel _____ mobile _____

email _____

name _____

address _____

_____ postcode _____

tel _____ mobile _____

email _____

◄◄ Village on the shore of the north pool of Lake Chad, Chad.
Photograph by Gordon Gahan

C

name _____
address _____

_____ postcode _____
tel _____ mobile _____
email _____

name _____
address _____

_____ postcode _____
tel _____ mobile _____
email _____

name _____
address _____

_____ postcode _____
tel _____ mobile _____
email _____

name _____
address _____

_____ postcode _____
tel _____ mobile _____
email _____

C

name _____
address _____

_____ postcode _____
tel _____ mobile _____
email _____

name _____
address _____

_____ postcode _____
tel _____ mobile _____
email _____

name _____
address _____

_____ postcode _____
tel _____ mobile _____
email _____

name _____
address _____

_____ postcode _____
tel _____ mobile _____
email _____

C

name _____

address _____

_____ postcode _____

tel _____ mobile _____

email _____

name _____

address _____

_____ postcode _____

tel _____ mobile _____

email _____

name _____

address _____

_____ postcode _____

tel _____ mobile _____

email _____

name _____

address _____

_____ postcode _____

tel _____ mobile _____

email _____

D

name _____
address _____

_____ postcode _____
tel _____ mobile _____
email _____

name _____
address _____

_____ postcode _____
tel _____ mobile _____
email _____

name _____
address _____

_____ postcode _____
tel _____ mobile _____
email _____

name _____
address _____

_____ postcode _____
tel _____ mobile _____
email _____

D

name _____

address _____

_____ postcode _____

tel _____ mobile _____

email _____

name _____

address _____

_____ postcode _____

tel _____ mobile _____

email _____

name _____

address _____

_____ postcode _____

tel _____ mobile _____

email _____

name _____

address _____

_____ postcode _____

tel _____ mobile _____

email _____

D

name _____

address _____

_____ postcode _____

tel _____ mobile _____

email _____

name _____

address _____

_____ postcode _____

tel _____ mobile _____

email _____

name _____

address _____

_____ postcode _____

tel _____ mobile _____

email _____

name _____

address _____

_____ postcode _____

tel _____ mobile _____

email _____

D

name _____
address _____

_____ postcode _____
tel _____ mobile _____
email _____

name _____
address _____

_____ postcode _____
tel _____ mobile _____
email _____

name _____
address _____

_____ postcode _____
tel _____ mobile _____
email _____

name _____
address _____

_____ postcode _____
tel _____ mobile _____
email _____

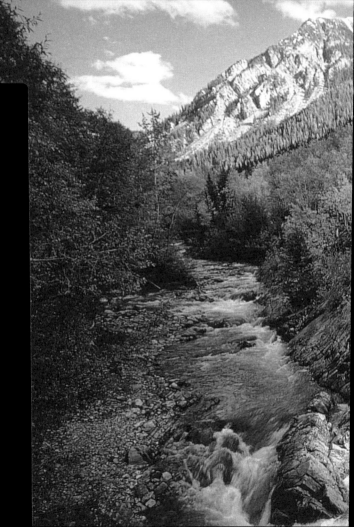

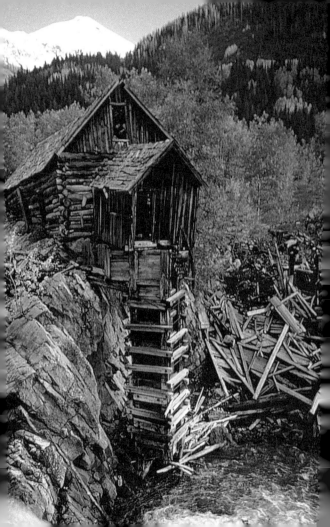

E

name _____

address _____

_____ postcode _____

tel _____ mobile _____

email _____

name _____

address _____

_____ postcode _____

tel _____ mobile _____

email _____

name _____

address _____

_____ postcode _____

tel _____ mobile _____

email _____

name _____

address _____

_____ postcode _____

tel _____ mobile _____

email _____

◄◄ Timber house above Crystal River, Colorado, U.S.A.
Photograph by Bruce Dale

E

name _____

address _____

_____ postcode _____

tel _____ mobile _____

email _____

name _____

address _____

_____ postcode _____

tel _____ mobile _____

email _____

name _____

address _____

_____ postcode _____

tel _____ mobile _____

email _____

name _____

address _____

_____ postcode _____

tel _____ mobile _____

email _____

E

name _____

address _____

_____ postcode _____

tel _____ mobile _____

email _____

name _____

address _____

_____ postcode _____

tel _____ mobile _____

email _____

name _____

address _____

_____ postcode _____

tel _____ mobile _____

email _____

name _____

address _____

_____ postcode _____

tel _____ mobile _____

email _____

E

name _____

address _____

_____ postcode _____

tel _____ mobile _____

email _____

name _____

address _____

_____ postcode _____

tel _____ mobile _____

email _____

name _____

address _____

_____ postcode _____

tel _____ mobile _____

email _____

name _____

address _____

_____ postcode _____

tel _____ mobile _____

email _____

F

name _____

address _____

_____ postcode _____

tel _____ mobile _____

email _____

name _____

address _____

_____ postcode _____

tel _____ mobile _____

email _____

name _____

address _____

_____ postcode _____

tel _____ mobile _____

email _____

name _____

address _____

_____ postcode _____

tel _____ mobile _____

email _____

F

name _____

address _____

_____ postcode _____

tel _____ mobile _____

email _____

name _____

address _____

_____ postcode _____

tel _____ mobile _____

email _____

name _____

address _____

_____ postcode _____

tel _____ mobile _____

email _____

name _____

address _____

_____ postcode _____

tel _____ mobile _____

email _____

F

name _____

address _____

_____ postcode _____

tel _____ mobile _____

email _____

name _____

address _____

_____ postcode _____

tel _____ _____ mobile _____

email _____

name _____

address _____

_____ postcode _____

tel _____ mobile _____

email _____

name _____

address _____

_____ postcode _____

tel _____ mobile _____

email _____

F

name _____

address _____

_____ postcode _____

tel _____ mobile _____

email _____

name _____

address _____

_____ postcode _____

tel _____ mobile _____

email _____

name _____

address _____

_____ postcode _____

tel _____ mobile _____

email _____

name _____

address _____

_____ postcode _____

tel _____ mobile _____

email _____

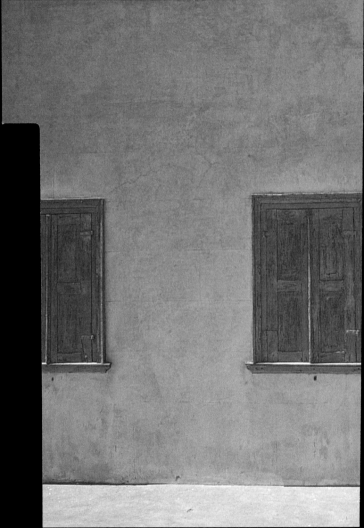

G

name _____

address _____

_____ postcode _____

tel _____ mobile _____

email _____

name _____

address _____

_____ postcode _____

tel _____ mobile _____

email _____

name _____

address _____

_____ postcode _____

tel _____ mobile _____

email _____

name _____

address _____

_____ postcode _____

tel _____ mobile _____

email _____

◄◄ Doorway and shuttered windows, Manolas, Thirasia Island, Greece.
Photograph by James P. Blair

G

name _____

address _____

_____ postcode _____

tel _____ mobile _____

email _____

name _____

address _____

_____ postcode _____

tel _____ mobile _____

email _____

name _____

address _____

_____ postcode _____

tel _____ mobile _____

email _____

name _____

address _____

_____ postcode _____

tel _____ mobile _____

email _____

G

name _____
address _____

_____ postcode _____
tel _____ mobile _____
email _____

name _____
address _____

_____ postcode _____
tel _____ mobile _____
email _____

name _____
address _____

_____ postcode _____
tel _____ mobile _____
email _____

name _____
address _____

_____ postcode _____
tel _____ mobile _____
email _____

G

name _____

address _____

_____ postcode _____

tel _____ mobile _____

email _____

name _____

address _____

_____ postcode _____

tel _____ mobile _____

email _____

name _____

address _____

_____ postcode _____

tel _____ mobile _____

email _____

name _____

address _____

_____ postcode _____

tel _____ mobile _____

email _____

H

name _____

address _____

_____ postcode _____

tel _____ mobile _____

email _____

name _____

address _____

_____ postcode _____

tel _____ mobile _____

email _____

name _____

address _____

_____ postcode _____

tel _____ mobile _____

email _____

name _____

address _____

_____ postcode _____

tel _____ mobile _____

email _____

H

name _____

address _____

_____ postcode _____

tel _____ mobile _____

email _____

name _____

address _____

_____ postcode _____

tel _____ mobile _____

email _____

name _____

address _____

_____ postcode _____

tel _____ mobile _____

email _____

name _____

address _____

_____ postcode _____

tel _____ mobile _____

email _____

H

name _____

address _____

_____ postcode _____

tel _____ mobile _____

email _____

name _____

address _____

_____ postcode _____

tel _____ mobile _____

email _____

name _____

address _____

_____ postcode _____

tel _____ mobile _____

email _____

name _____

address _____

_____ postcode _____

tel _____ mobile _____

email _____

H

name _____

address _____

_____ postcode _____

tel _____ mobile _____

email _____

name _____

address _____

_____ postcode _____

tel _____ mobile _____

email _____

name _____

address _____

_____ postcode _____

tel _____ mobile _____

email _____

name _____

address _____

_____ postcode _____

tel _____ mobile _____

email _____

I

name _____

address _____

_____ postcode _____

tel _____ mobile _____

email _____

name _____

address _____

_____ postcode _____

tel _____ mobile _____

email _____

name _____

address _____

_____ postcode _____

tel _____ mobile _____

email _____

name _____

address _____

_____ postcode _____

tel _____ mobile _____

email _____

◄◄ Thatched houses, Surui, Amazon River Basin, Brazil.
Photograph by James P. Blair

I

name _____
address _____

_____ postcode _____
tel _____ mobile _____
email _____

name _____
address _____

_____ postcode _____
tel _____ mobile _____
email _____

name _____
address _____

_____ postcode _____
tel _____ mobile _____
email _____

name _____
address _____

_____ postcode _____
tel _____ mobile _____
email _____

I

name _____

address _____

_____ postcode _____

tel _____ mobile _____

email _____

name _____

address _____

_____ postcode _____

tel _____ mobile _____

email _____

name _____

address _____

_____ postcode _____

tel _____ mobile _____

email _____

name _____

address _____

_____ postcode _____

tel _____ mobile _____

email _____

I

name _____

address _____

_____ postcode _____

tel _____ mobile _____

email _____

name _____

address _____

_____ postcode _____

tel _____ mobile _____

email _____

name _____

address _____

_____ postcode _____

tel _____ mobile _____

email _____

name _____

address _____

_____ postcode _____

tel _____ mobile _____

email _____

J

name _____

address _____

_____ postcode _____

tel _____ mobile _____

email _____

name _____

address _____

_____ postcode _____

tel _____ mobile _____

email _____

name _____

address _____

_____ postcode _____

tel _____ mobile _____

email _____

name _____

address _____

_____ postcode _____

tel _____ mobile _____

email _____

J

name _____

address _____

_____ postcode _____

tel _____ mobile _____

email _____

name _____

address _____

_____ postcode _____

tel _____ mobile _____

email _____

name _____

address _____

_____ postcode _____

tel _____ mobile _____

email _____

name _____

address _____

_____ postcode _____

tel _____ mobile _____

email _____

J

name _____

address _____

_____ postcode _____

tel _____ mobile _____

email _____

name _____

address _____

_____ postcode _____

tel _____ mobile _____

email _____

name _____

address _____

_____ postcode _____

tel _____ mobile _____

email _____

name _____

address _____

_____ postcode _____

tel _____ mobile _____

email _____

J

name _____

address _____

_____ postcode _____

tel _____ mobile _____

email _____

name _____

address _____

_____ postcode _____

tel _____ mobile _____

email _____

name _____

address _____

_____ postcode _____

tel _____ mobile _____

email _____

name _____

address _____

_____ postcode _____

tel _____ mobile _____

email _____

K

name _____

address _____

_____ postcode _____

tel _____ mobile _____

email _____

name _____

address _____

_____ postcode _____

tel _____ mobile _____

email _____

name _____

address _____

_____ postcode _____

tel _____ mobile _____

email _____

name _____

address _____

_____ postcode _____

tel _____ mobile _____

email _____

◀◀ A framework of branches forms the basis of an aboriginal shelter, Australia.
Photograph by Joe Scherschel

K

name _____

address _____

_____ postcode _____

tel _____ mobile _____

email _____

name _____

address _____

_____ postcode _____

tel _____ mobile _____

email _____

name _____

address _____

_____ postcode _____

tel _____ mobile _____

email _____

name _____

address _____

_____ postcode _____

tel _____ mobile _____

email _____

K

name _____

address _____

_____ postcode _____

tel _____ mobile _____

email _____

name _____

address _____

_____ postcode _____

tel _____ mobile _____

email _____

name _____

address _____

_____ postcode _____

tel _____ mobile _____

email _____

name _____

address _____

_____ postcode _____

tel _____ mobile _____

email _____

K

name _____

address _____

_____ postcode _____

tel _____ mobile _____

email _____

name _____

address _____

_____ postcode _____

tel _____ mobile _____

email _____

name _____

address _____

_____ postcode _____

tel _____ mobile _____

email _____

name _____

address _____

_____ postcode _____

tel _____ mobile _____

email _____

L

name _____
address _____

_____ postcode _____
tel _____ mobile _____
email _____

name _____
address _____

_____ postcode _____
tel _____ mobile _____
email _____

name _____
address _____

_____ postcode _____
tel _____ mobile _____
email _____

name _____
address _____

_____ postcode _____
tel _____ mobile _____
email _____

L

name _____
address _____

_____ postcode _____
tel _____ mobile _____
email _____

name _____
address _____

_____ postcode _____
tel _____ mobile _____
email _____

name _____
address _____

_____ postcode _____
tel _____ mobile _____
email _____

name _____
address _____

_____ postcode _____
tel _____ mobile _____
email _____

L

name _____

address _____

_____ postcode _____

tel _____ mobile _____

email _____

name _____

address _____

_____ postcode _____

tel _____ mobile _____

email _____

name _____

address _____

_____ postcode _____

tel _____ mobile _____

email _____

name _____

address _____

_____ postcode _____

tel _____ mobile _____

email _____

L

name _____

address _____

_____ postcode _____

tel _____ mobile _____

email _____

name _____

address _____

_____ postcode _____

tel _____ mobile _____

email _____

name _____

address _____

_____ postcode _____

tel _____ mobile _____

email _____

name _____

address _____

_____ postcode _____

tel _____ mobile _____

email _____

M

name _____
address _____

_____ postcode _____
tel _____ mobile _____
email _____

name _____
address _____

_____ postcode _____
tel _____ mobile _____
email _____

name _____
address _____

_____ postcode _____
tel _____ mobile _____
email _____

name _____
address _____

_____ postcode _____
tel _____ mobile _____
email _____

◄◄ Reflections of houses and the tips of gondolas in a canal, Venice, Italy.
Photograph by Jodi Cobb

M

name _____
address _____

_____ postcode _____
tel _____ mobile _____
email _____

name _____
address _____

_____ postcode _____
tel _____ mobile _____
email _____

name _____
address _____

_____ postcode _____
tel _____ mobile _____
email _____

name _____
address _____

_____ postcode _____
tel _____ mobile _____
email _____

M

name _____

address _____

_____ postcode _____

tel _____ mobile _____

email _____

name _____

address _____

_____ postcode _____

tel _____ mobile _____

email _____

name _____

address _____

_____ postcode _____

tel _____ mobile _____

email _____

name _____

address _____

_____ postcode _____

tel _____ mobile _____

email _____

M

name _____

address _____

_____ postcode _____

tel _____ mobile _____

email _____

name _____

address _____

_____ postcode ___ _____

tel _____ mobile _____

email _____

name _____

address _____

_____ postcode _____

tel _____ mobile _____

email _____

name _____

address _____

_____ postcode _____

tel _____ mobile _____

email _____

N

name _____
address _____

_____ postcode _____
tel _____ mobile _____
email _____

name _____
address _____

_____ postcode _____
tel _____ mobile _____
email _____

name _____
address _____

_____ postcode _____
tel _____ mobile _____
email _____

name _____
address _____

_____ postcode _____
tel _____ mobile _____
email _____

N

name _____
address _____

_____ postcode _____
tel _____ mobile _____
email _____

name _____
address _____

_____ postcode _____
tel _____ mobile _____
email _____

name _____
address _____

_____ postcode _____
tel _____ mobile _____
email _____

name _____
address _____

_____ postcode _____
tel _____ mobile _____
email _____

N

name _____
address _____

_____ postcode _____
tel _____ mobile _____
email _____

name _____
address _____

_____ postcode _____
tel _____ mobile _____
email _____

name _____
address _____

_____ postcode _____
tel _____ mobile _____
email _____

name _____
address _____

_____ postcode _____
tel _____ mobile _____
email _____

N

name _____

address _____

_____ postcode _____

tel _____ mobile _____

email _____

name _____

address _____

_____ postcode _____

tel _____ mobile _____

email _____

name _____

address _____

_____ postcode _____

tel _____ mobile _____

email _____

name _____

address _____

_____ postcode _____

tel _____ mobile _____

email _____

O

name _____
address _____

_____ postcode _____
tel _____ mobile _____
email _____

name _____
address _____

_____ postcode _____
tel _____ mobile _____
email _____

name _____
address _____

_____ postcode _____
tel _____ mobile _____
email _____

name _____
address _____

_____ postcode _____
tel _____ mobile _____
email _____

◄◄ Homestead in the Sambeto Mountains, Viti Levu Island, Fiji Islands.
Photograph by James L. Stanfield

name _____

address _____

_____ postcode _____

tel _____ mobile _____

email _____

name _____

address _____

_____ postcode _____

tel _____ mobile _____

email _____

name _____

address _____

_____ postcode _____

tel _____ mobile _____

email _____

name _____

address _____

_____ postcode _____

tel _____ mobile _____

email _____

name _____

address _____

_____ postcode _____

tel _____ mobile _____

email _____

name _____

address _____

_____ postcode _____

tel _____ mobile _____

email _____

name _____

address _____

_____ postcode _____

tel _____ mobile _____

email _____

name _____

address _____

_____ postcode _____

tel _____ mobile _____

email _____

name _____

address _____

_____ postcode _____

tel _____ mobile _____

email _____

name _____

address _____

_____ postcode _____

tel _____ mobile _____

email _____

name _____

address _____

_____ postcode _____

tel _____ mobile _____

email _____

name _____

address _____

_____ postcode _____

tel _____ mobile _____

email _____

P

name _____

address _____

_____ postcode _____

tel _____ mobile _____

email _____

name _____

address _____

_____ postcode _____

tel _____ mobile _____

email _____

name _____

address _____

_____ postcode _____

tel _____ mobile _____

email _____

name _____

address _____

_____ postcode _____

tel _____ mobile _____

email _____

P

name _____

address _____

_____ postcode _____

tel _____ _____ mobile _____

email _____

name _____

address _____

_____ postcode _____

tel _____ mobile _____

email _____

name _____

address _____

_____ postcode _____

tel _____ mobile _____

email _____

name _____

address _____

_____ postcode _____

tel _____ mobile _____

email _____

P

name _____

address _____

_____ postcode _____

tel _____ mobile _____

email _____

name _____

address _____

_____ postcode _____

tel _____ mobile _____

email _____

name _____

address _____

_____ postcode _____

tel _____ mobile _____

email _____

name _____

address _____

_____ postcode _____

tel _____ mobile _____

email _____

P

name _____

address _____

_____ postcode _____

tel _ _____ mobile _____

email _____ _____

name _____

address _____

_____ postcode _____

tel _____ mobile _____

email _____

name _____

address _____

_____ postcode _____

tel _____ mobile _____

email _____

name _____

address _____

_____ postcode _____

tel _____ mobile _____

email _____

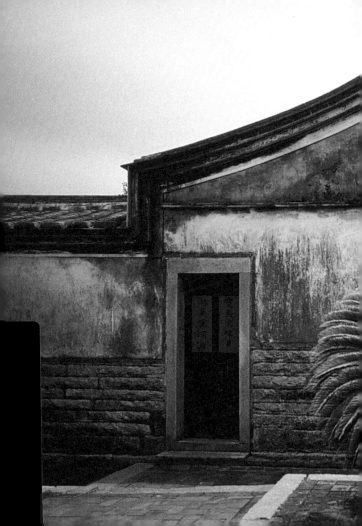

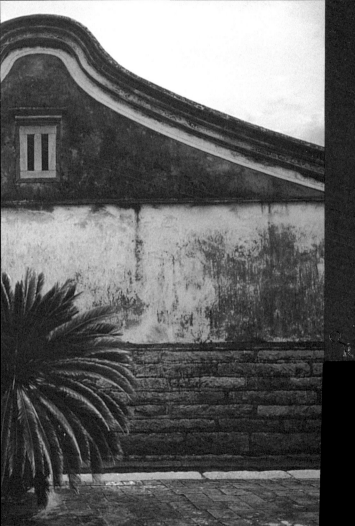

name _____

address _____

_____ postcode _____

tel _____ mobile _____

email _____

name _____

address _____

_____ postcode _____

tel _____ mobile _____

email _____

name _____

address _____

_____ postcode _____

tel _____ mobile _____

email _____

name _____

address _____

_____ postcode _____

tel _____ mobile _____

email _____

◄◄ Courtyard, Kinman Island, Taiwan.
Photograph by Jodi Cobb

name _____

address _____

_____ postcode _____

tel _____ mobile _____

email _____

name _____

address _____

_____ postcode _____

tel _____ mobile _____

email _____

name _____

address _____

_____ postcode _____

tel _____ mobile _____

email _____

name _____

address _____

_____ postcode _____

tel _____ mobile _____

email _____

name _____

address _____

_____ postcode _____

tel _____ mobile _____

email _____

name _____

address _____

_____ postcode _____

tel _____ mobile _____

email _____

name _____

address _____

_____ postcode _____

tel _____ mobile _____

email _____

name _____

address _____

_____ postcode _____

tel _____ mobile _____

email _____

name _____

address _____

_____ postcode _____

tel _____ mobile _____

email _____

name _____

address _____

_____ postcode _____

tel _____ mobile _____

email _____

name _____

address _____

_____ postcode _____

tel _____ mobile _____

email _____

name _____

address _____

_____ postcode _____

tel _____ mobile _____

email _____

R

name _____

address _____

_____ postcode _____

tel _____ mobile _____

email _____

name _____

address _____

_____ postcode _____

tel _____ mobile _____

email _____

name _____

address _____

_____ postcode _____

tel _____ mobile _____

email _____

name _____

address _____

_____ postcode _____

tel _____ mobile _____

email _____

R

name _____
address _____

_____ postcode _____
tel _____ mobile _____
email _____

name _____
address _____

_____ postcode _____
tel _____ mobile _____
email _____

name _____
address _____

_____ postcode _____
tel _____ mobile _____
email _____

name _____
address _____

_____ postcode _____
tel _____ mobile _____
email _____

R

name _____
address _____

_____ postcode _____
tel _____ mobile _____
email _____

name _____
address _____

_____ postcode _____
tel _____ mobile _____
email _____

name _____
address _____

_____ postcode _____
tel _____ mobile _____
email _____

name _____
address _____

_____ postcode _____
tel _____ mobile _____
email _____

R

name _____
address _____

_____ postcode _____
tel _____ mobile _____
email _____

name _____
address _____

_____ postcode _____
tel _____ mobile _____
email _____

name _____
address _____

_____ postcode _____
tel _____ mobile _____
email _____

name _____
address _____

_____ postcode _____
tel _____ mobile _____
email _____

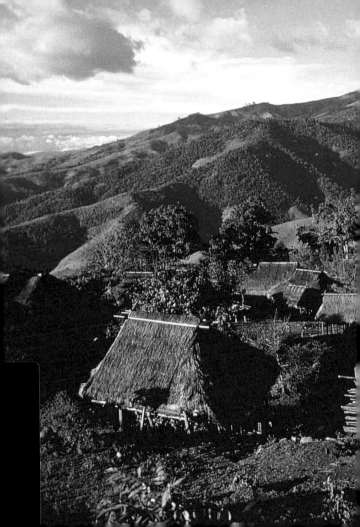

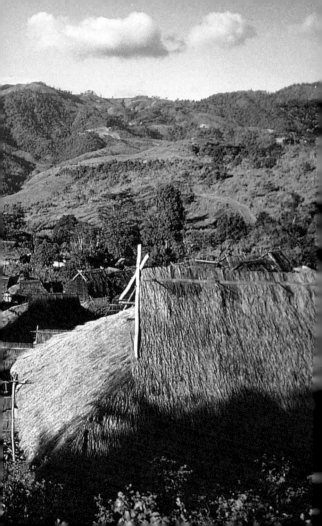

S

name _____

address _____

_____ postcode _____

tel _____ mobile _____

email _____

name _____

address _____

_____ postcode _____

tel _____ mobile _____

email _____

name _____

address _____

_____ postcode _____

tel _____ mobile _____

email _____

name _____

address _____

_____ postcode _____

tel _____ mobile _____

email _____

◄◄ Thatched huts, Golden Triangle, Thailand.
Photograph by Steve Raymer

S

name _____

address _____

_____ postcode _____

tel _____ mobile _____

email _____

name _____

address _____

_____ postcode _____

tel _____ mobile _____

email _____

name _____

address _____

_____ postcode _____

tel _____ mobile _____

email _____

name _____

address _____

_____ postcode _____

tel _____ mobile _____

email _____

S

name _____
address _____

_____ postcode _____
tel _____ mobile _____
email _____

name _____
address _____

_____ postcode _____
tel _____ mobile _____
email _____

name _____
address _____

_____ postcode _____
tel _____ mobile _____
email _____

name _____
address _____

_____ postcode _____
tel _____ mobile _____
email _____

S

name _____

address _____

_____ postcode _____

tel _____ mobile _____

email _____

name _____

address _____

_____ postcode _____

tel _____ mobile _____

email _____

name _____

address _____

_____ postcode _____

tel _____ mobile _____

email _____

name _____

address _____

_____ postcode _____

tel _____ mobile _____

email _____

T

name _____
address _____

_____ postcode _____
tel _____ mobile _____
email _____

name _____
address _____

_____ postcode _____
tel _____ mobile _____
email _____

name _____
address _____

_____ postcode _____
tel _____ mobile _____
email _____

name _____
address _____

_____ postcode _____
tel _____ mobile _____
email _____

T

name _____
address _____

_____ postcode _____
tel _____ mobile _____
email _____

name _____
address _____

_____ postcode _____
tel _____ mobile _____
email _____

name _____
address _____

_____ postcode _____
tel _____ mobile _____
email _____

name _____
address _____

_____ postcode _____
tel _____ mobile _____
email _____

T

name _____
address _____

_____ postcode _____
tel _____ mobile _____
email _____

name _____
address _____

_____ postcode _____
tel _____ mobile _____
email _____

name _____
address _____

_____ postcode _____
tel _____ mobile _____
email _____

name _____
address _____

_____ postcode _____
tel _____ mobile _____
email _____

T

name _____
address _____

_____ postcode _____
tel _____ mobile _____
email _____

name _____
address _____

_____ postcode _____
tel _____ mobile _____
email _____

name _____
address _____

_____ postcode _____
tel _____ mobile _____
email _____

name _____
address _____

_____ postcode _____
tel _____ mobile _____
email _____

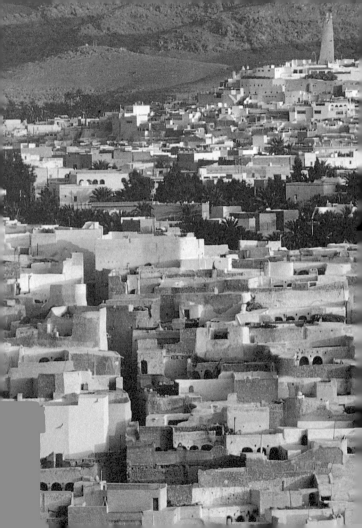

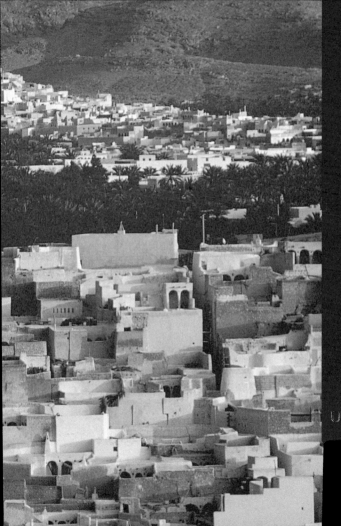

U

name _____
address _____

_____ postcode _____
tel _____ mobile _____
email _____

name _____
address _____

_____ postcode _____
tel _____ mobile _____
email _____

name _____
address _____

_____ postcode _____
tel _____ mobile _____
email _____

name _____
address _____

_____ postcode _____
tel _____ mobile _____
email _____

◀◀ Thardaia, M'zab Valley, Algeria.
Photograph by Thomas J. Abercrombie

U

name _____

address _____

_____ postcode _____

tel _____ mobile _____

email _____

name _____

address _____

_____ postcode _____

tel _____ mobile _____

email _____

name _____

address _____

_____ postcode _____

tel _____ mobile _____

email _____

name _____

address _____

_____ postcode _____

tel _____ mobile _____

email _____

U

name _____
address _____

_____ postcode _____
tel _____ mobile _____
email _____

name _____
address _____

_____ postcode _____
tel _____ mobile _____
email _____

name _____
address _____

_____ postcode _____
tel _____ mobile _____
email _____

name _____
address _____

_____ postcode _____
tel _____ mobile _____
email _____

U

name _____

address _____

_____ postcode _____

tel _____ mobile _____

email _____

name _____

address _____

_____ postcode _____

tel _____ mobile _____

email _____

name _____

address _____

_____ postcode _____

tel _____ mobile _____

email _____

name _____

address _____

_____ postcode _____

tel _____ mobile _____

email _____

V

name _____

address _____

_____ postcode _____

tel _____ mobile _____

email _____

name _____

address _____

_____ postcode _____

tel _____ mobile _____

email _____

name _____

address _____

_____ postcode _____

tel _____ mobile _____

email _____

name _____

address _____

_____ postcode _____

tel _____ mobile _____

email _____

V

name _____

address _____

_____ postcode _____

tel _____ mobile _____

email _____

name _____

address _____

_____ postcode _____

tel _____ mobile _____

email _____

name _____

address _____

_____ postcode _____

tel _____ mobile _____

email _____

name _____

address _____

_____ postcode _____

tel _____ mobile _____

email _____

V

name _____

address _____

_____ postcode _____

tel _____ mobile _____

email _____

name _____

address _____

_____ postcode _____

tel _____ mobile _____

email _____

name _____

address _____

_____ postcode _____

tel _____ mobile _____

email _____

name _____

address _____

_____ postcode _____

tel _____ mobile _____

email _____

V

name _____

address _____

_____ postcode _____

tel _____ mobile _____

email _____

name _____

address _____

_____ postcode _____

tel _____ mobile _____

email _____

name _____

address _____

_____ postcode _____

tel _____ mobile _____

email _____

name _____

address _____

_____ postcode _____

tel _____ mobile _____

email _____

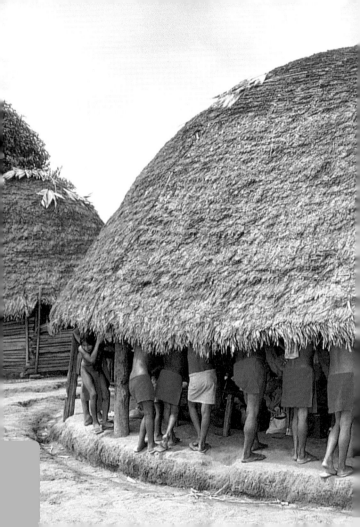

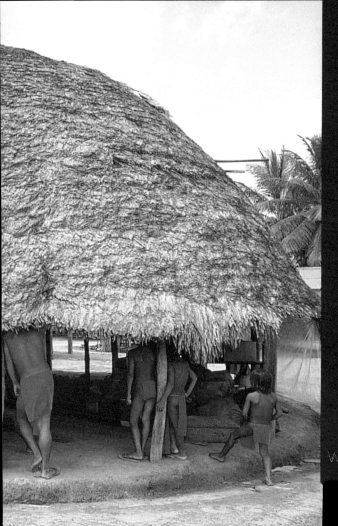

W

name _____

address _____

_____ postcode _____

tel _____ mobile _____

email _____

name _____

address _____

_____ postcode _____

tel _____ mobile _____

email _____

name _____

address _____

_____ postcode _____

tel _____ mobile _____

email _____

name _____

address _____

_____ postcode _____

tel _____ mobile _____

email _____

◄◄ Central village hut of the Tirio Indians, Tepoe, Tapanahoni River, Suriname.
Photograph by Jon T. Schneeberger

W

name _____
address _____

_____ postcode _____
tel _____ mobile _____
email _____

name _____
address _____

_____ postcode _____
tel _____ mobile _____
email _____

name _____
address _____

_____ postcode _____
tel _____ mobile _____
email _____

name _____
address _____

_____ postcode _____
tel _____ mobile _____
email _____

W

name _____

address _____

_____ postcode _____

tel _____ mobile _____

email _____

name _____

address _____

_____ postcode _____

tel _____ mobile _____

email _____

name _____

address _____

_____ postcode _____

tel _____ mobile _____

email _____

name _____

address _____

_____ postcode _____

tel _____ mobile _____

email _____

W

name _____

address _____

_____ postcode _____

tel _____ mobile _____

email _____

name _____

address _____

_____ postcode _____

tel _____ mobile _____

email _____

name _____

address _____

_____ postcode _____

tel _____ mobile _____

email _____

name _____

address _____

_____ postcode _____

tel _____ mobile _____

email _____

X

name _____
address _____

_____ postcode _____
tel _____ mobile _____
email _____

name _____
address _____

_____ postcode _____
tel _____ mobile _____
email _____

name _____
address _____

_____ postcode _____
tel _____ mobile _____
email _____

name _____
address _____

_____ postcode _____
tel _____ mobile _____
email _____

X

name _____

address _____

_____ postcode _____

tel _____ mobile _____

email _____

name _____

address _____

_____ postcode _____

tel _____ mobile _____

email _____

name _____

address _____

_____ postcode _____

tel _____ mobile _____

email _____

name _____

address _____

_____ postcode _____

tel _____ mobile _____

email _____

X

name _____
address _____

_____ postcode _____
tel _____ mobile _____
email _____

name _____
address _____

_____ postcode _____
tel _____ mobile _____
email _____

name _____
address _____

_____ postcode _____
tel _____ mobile _____
email _____

name _____
address _____

_____ postcode _____
tel _____ mobile _____
email _____

X

name _____

address _____

_____ postcode _____

tel _____ mobile _____

email _____

name _____

address _____

_____ postcode _____

tel _____ mobile _____

email _____

name _____

address _____

_____ postcode _____

tel _____ mobile _____

email _____

name _____

address _____

_____ postcode _____

tel _____ mobile _____

email _____

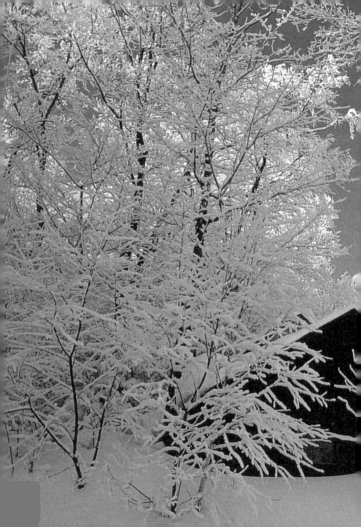